COLOR THE Natural World

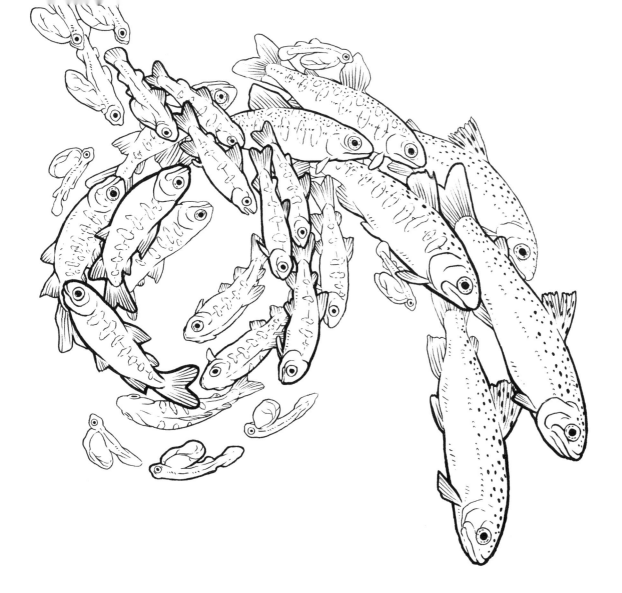

COLOR THE
Natural World

a **TIMBER PRESS** *coloring book*

Zoe Keller

Timber Press | Portland, Oregon

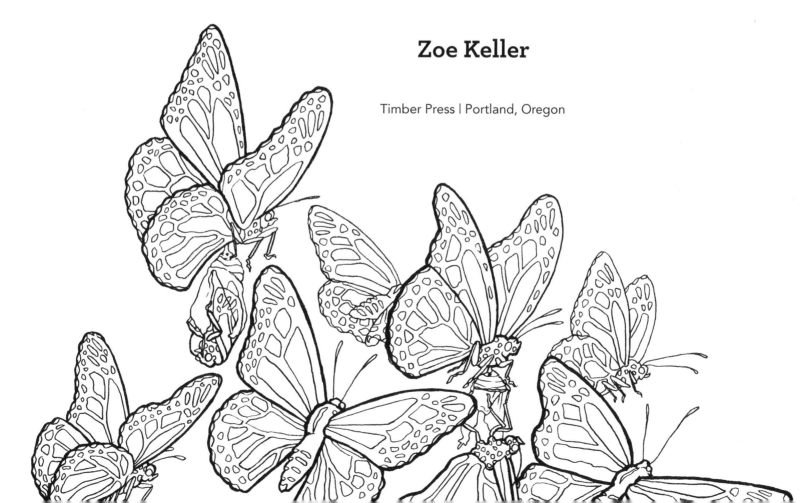

Color your way through the natural world—from the temperate forests of the Northwest, the rocky shores of the Pacific Coast, and the deserts of the Southwest to the Gulf Coastal Plain and the rich forests of Appalachia and the Northeast.

As you journey from place to place, look for the flora and fauna that link each ecosystem to the next.

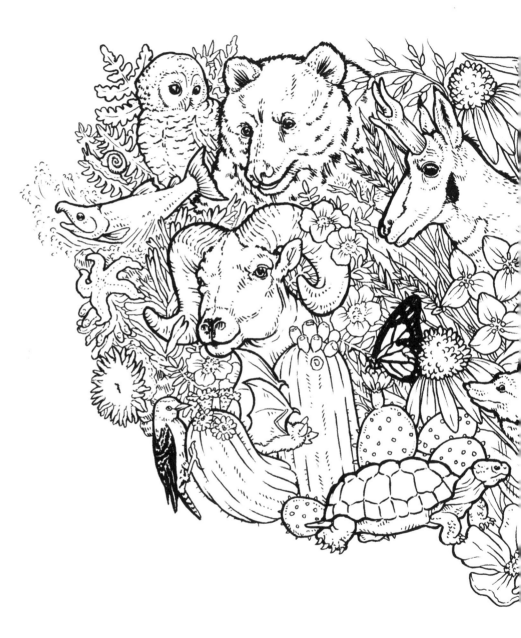

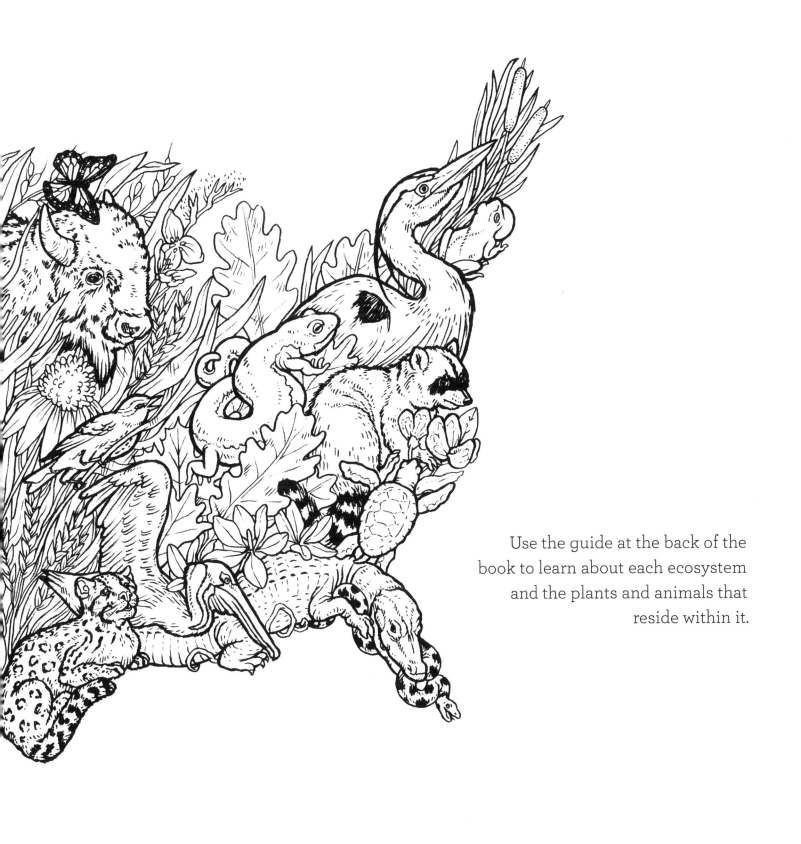

Use the guide at the back of the book to learn about each ecosystem and the plants and animals that reside within it.

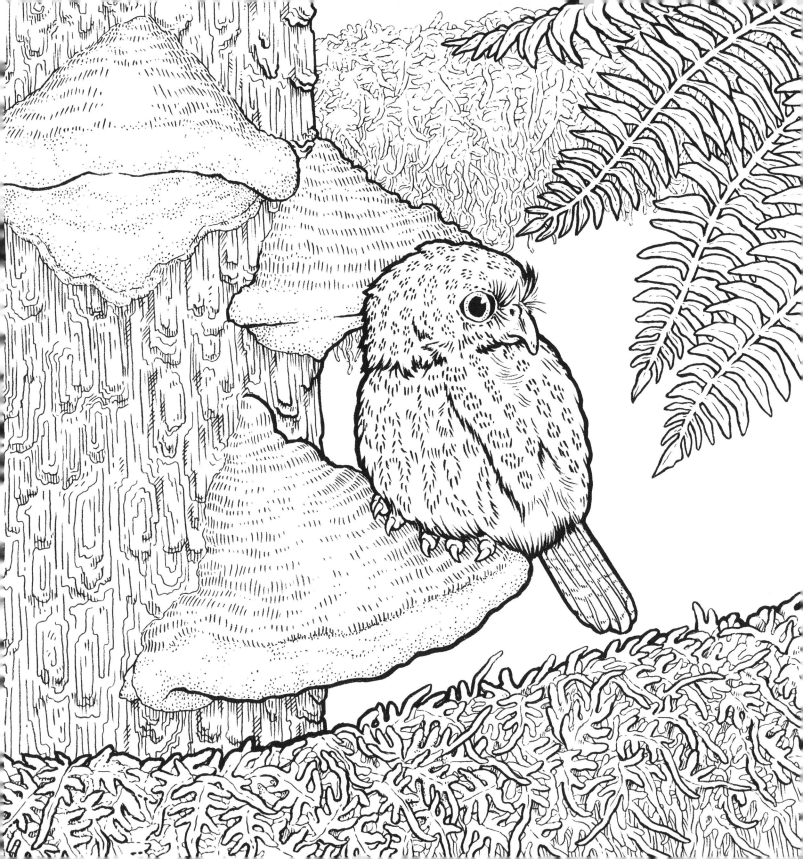

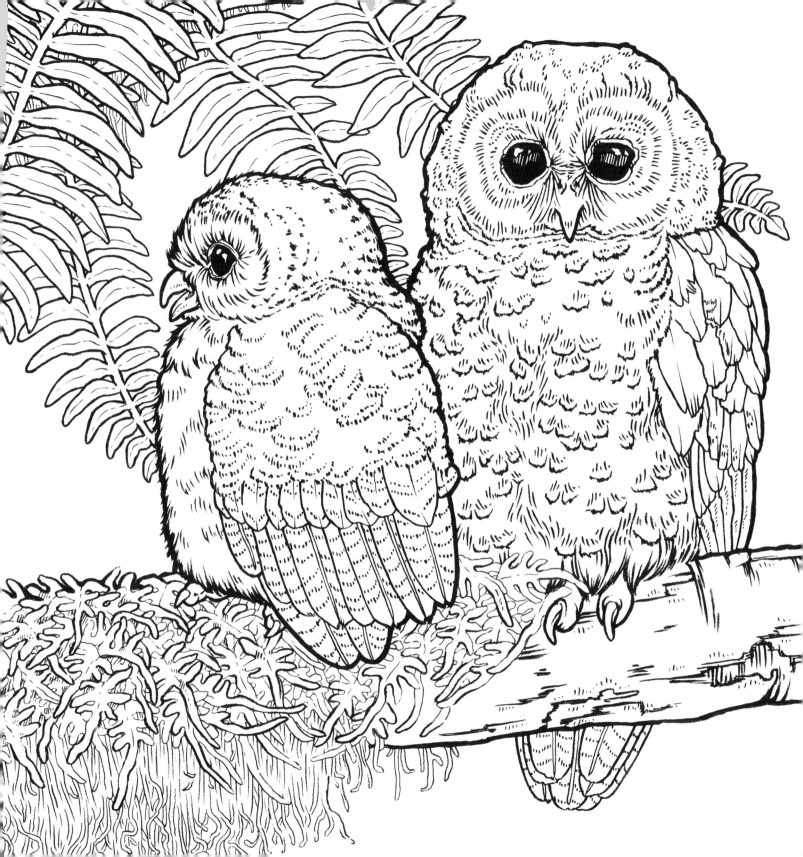

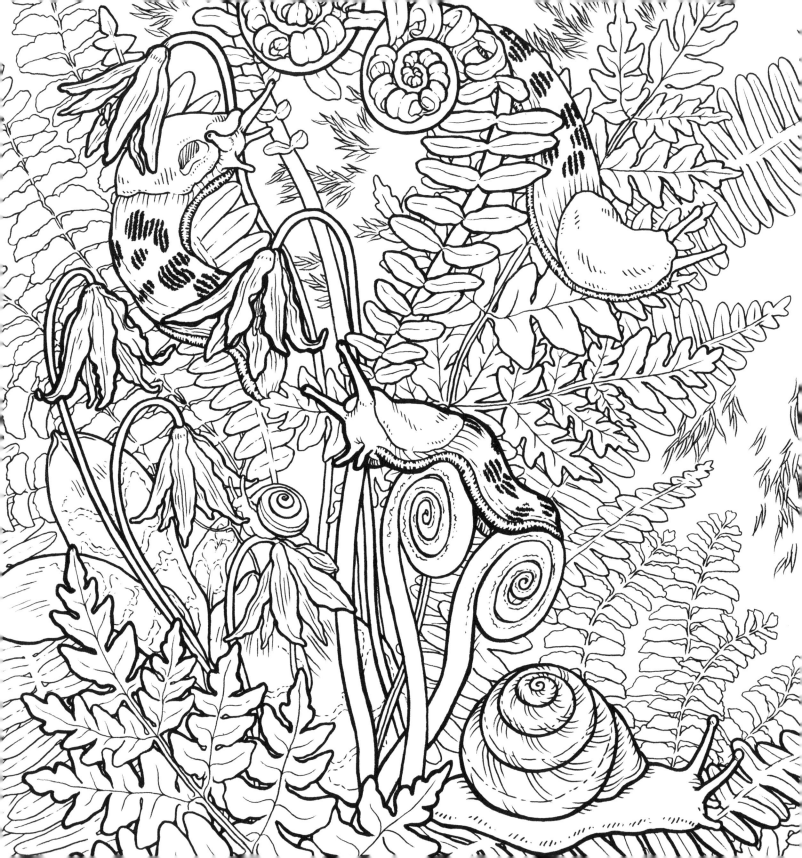

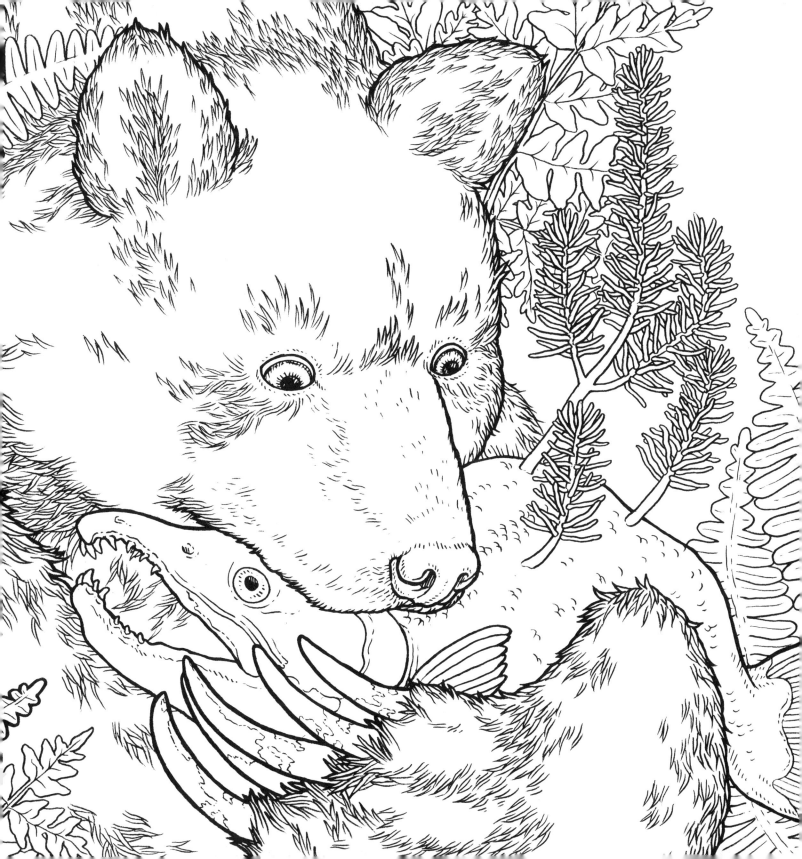

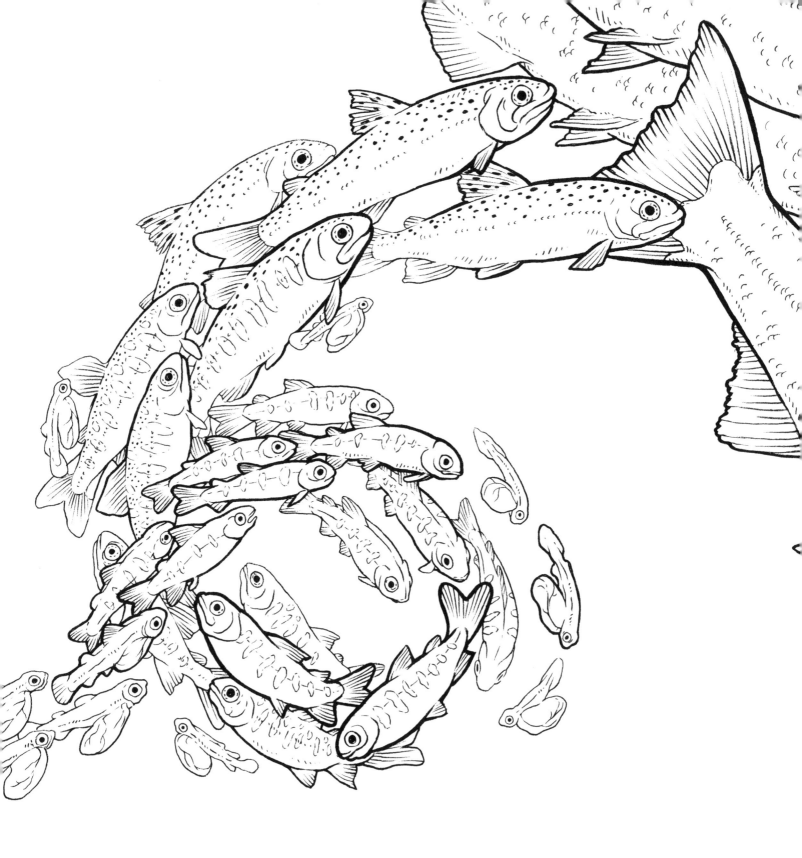

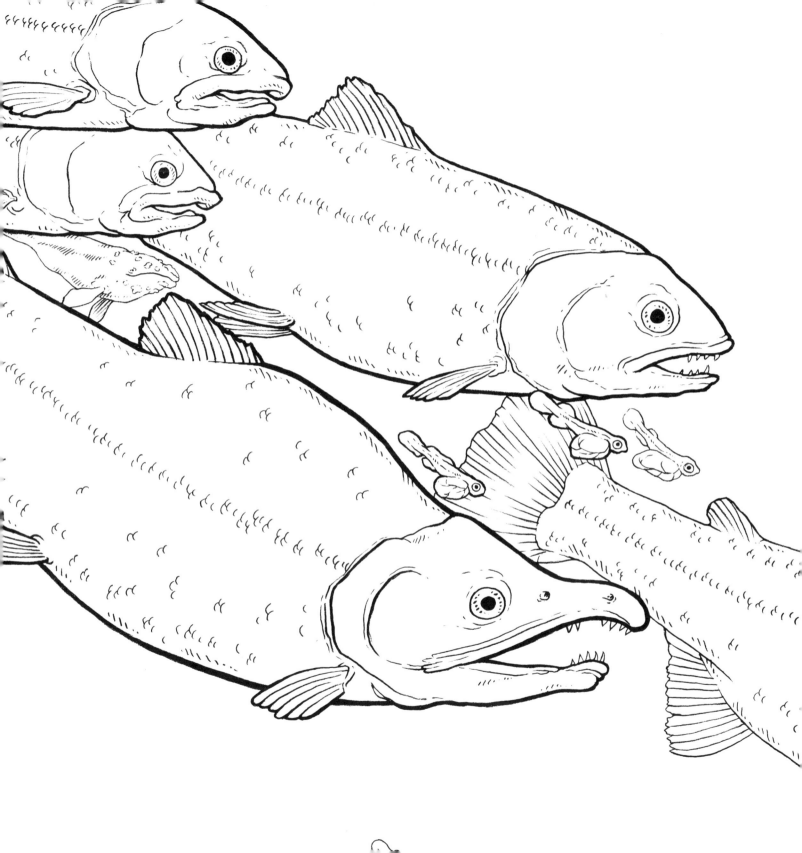

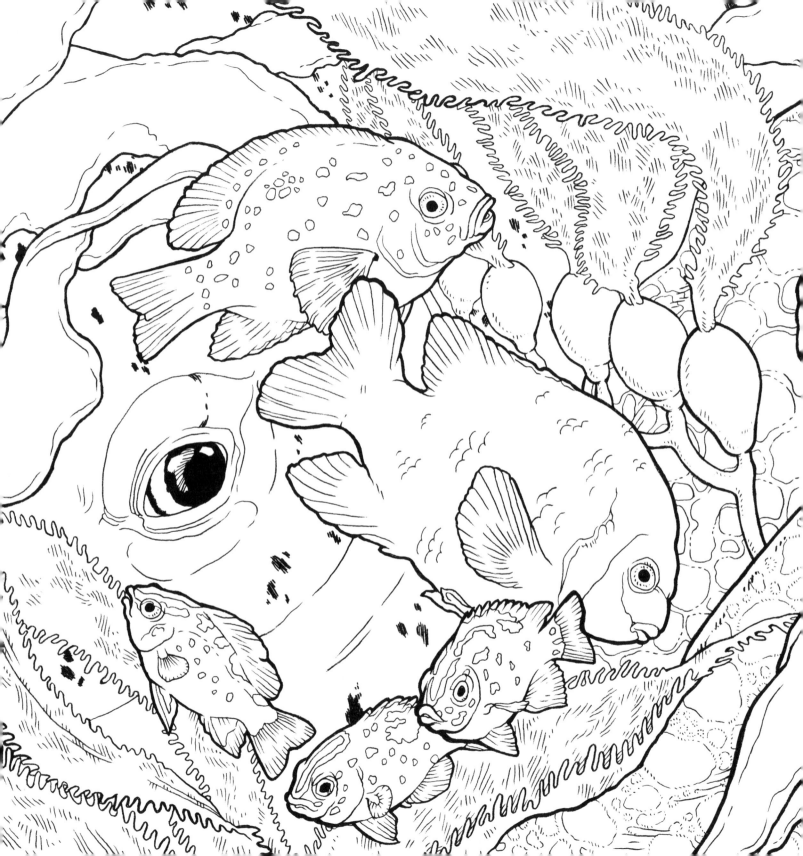

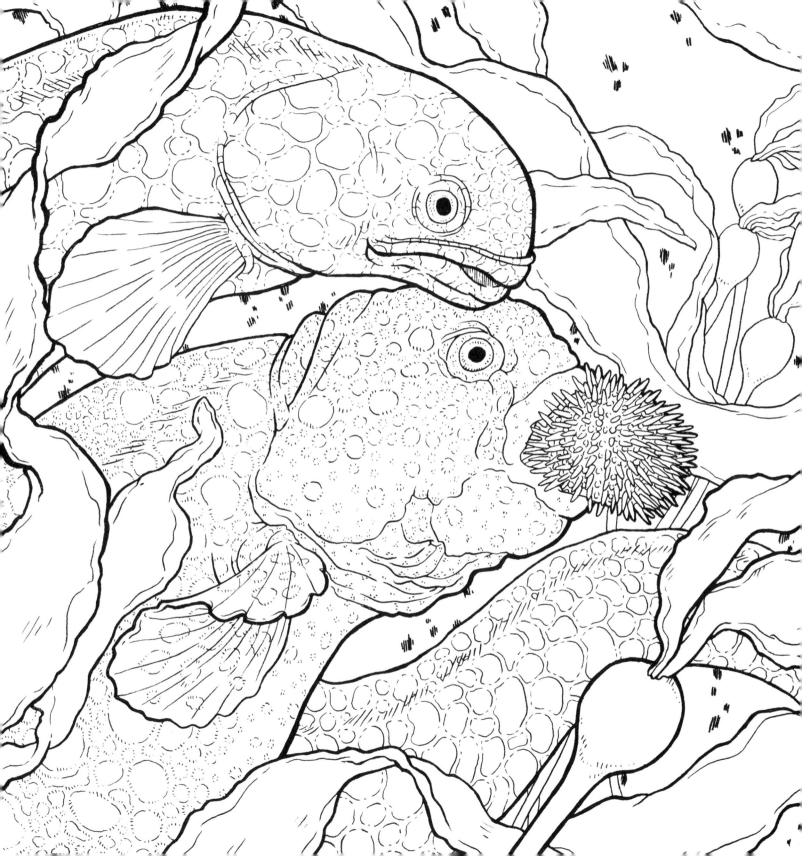

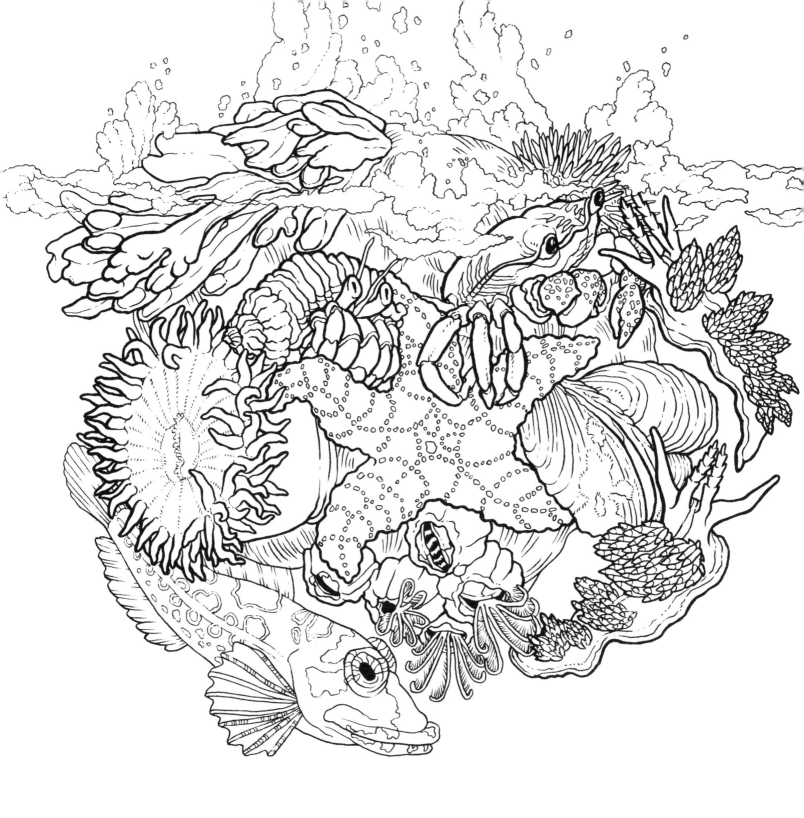

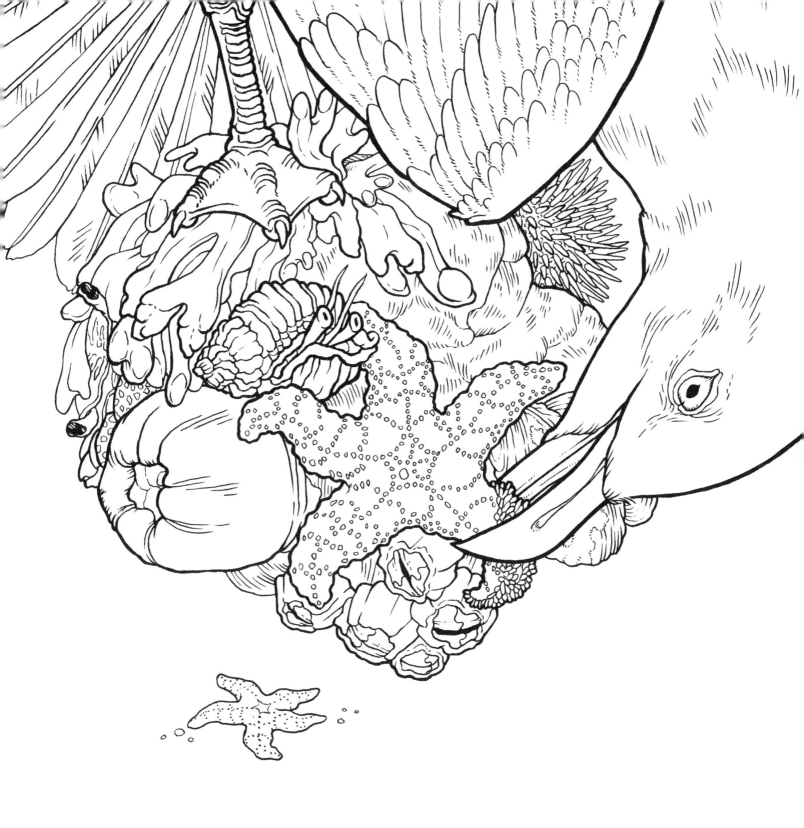

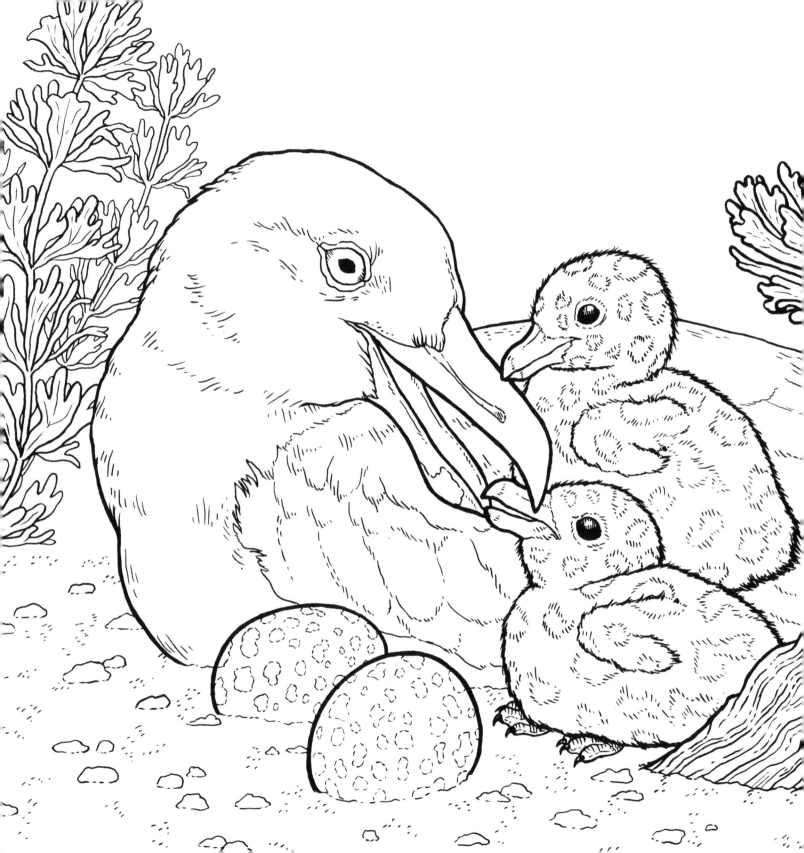

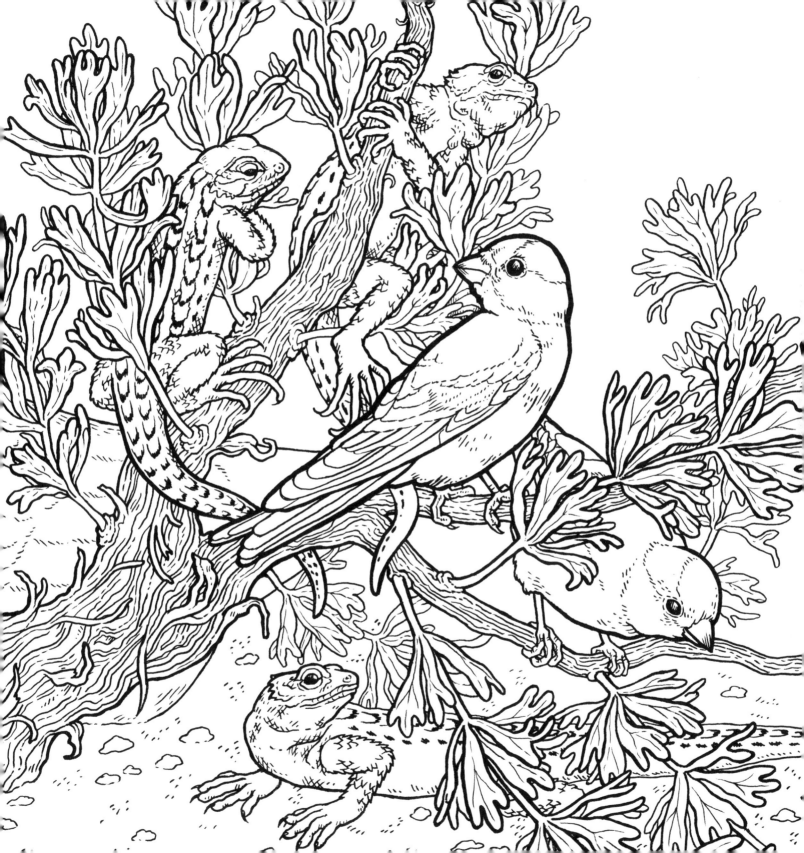

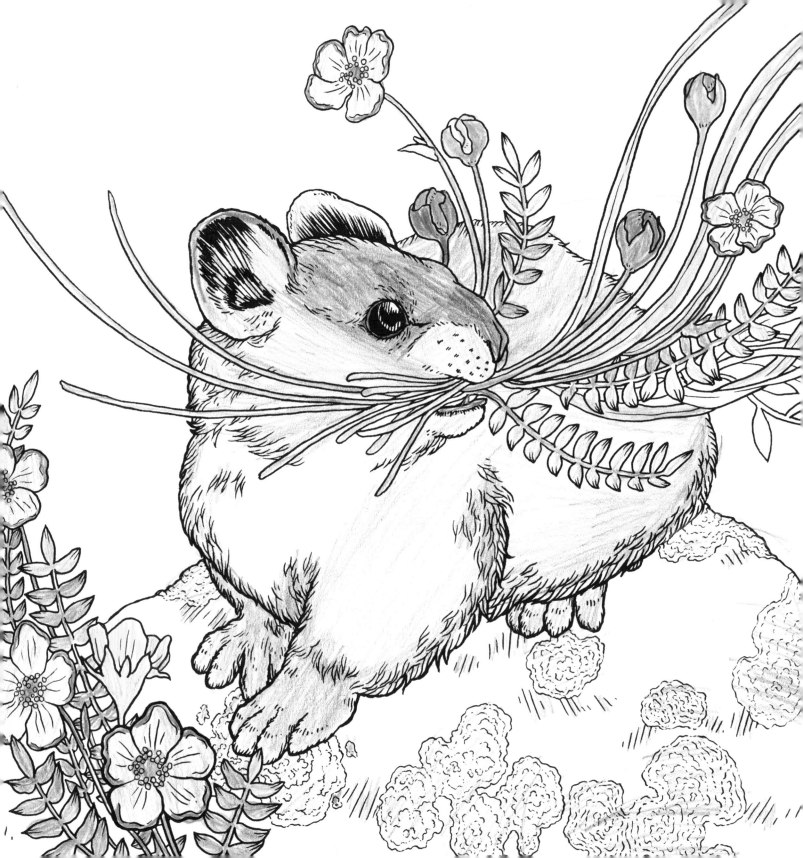

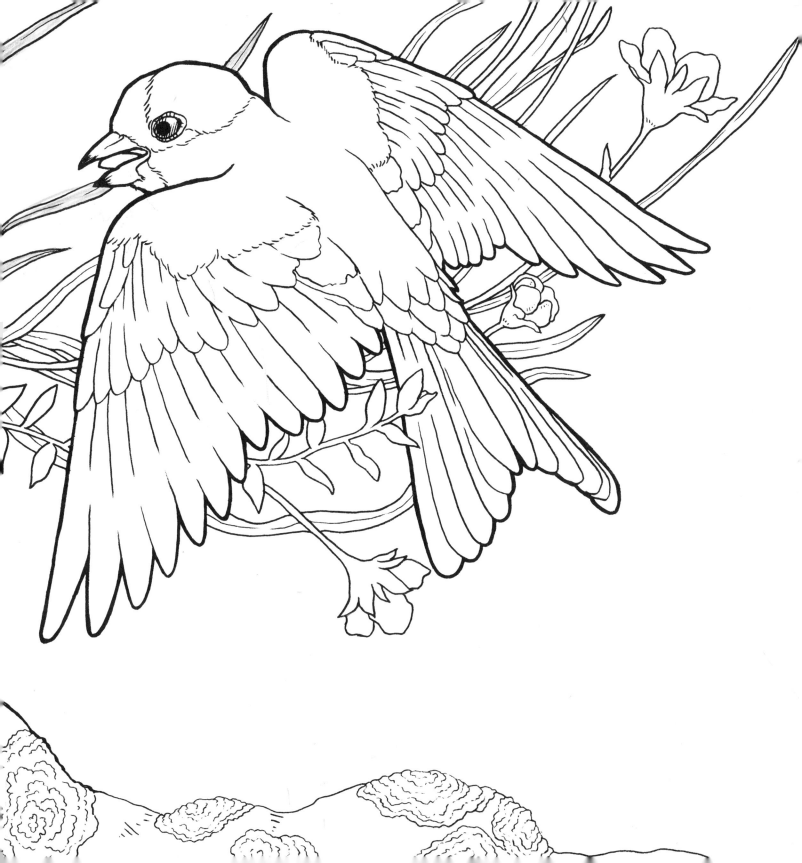

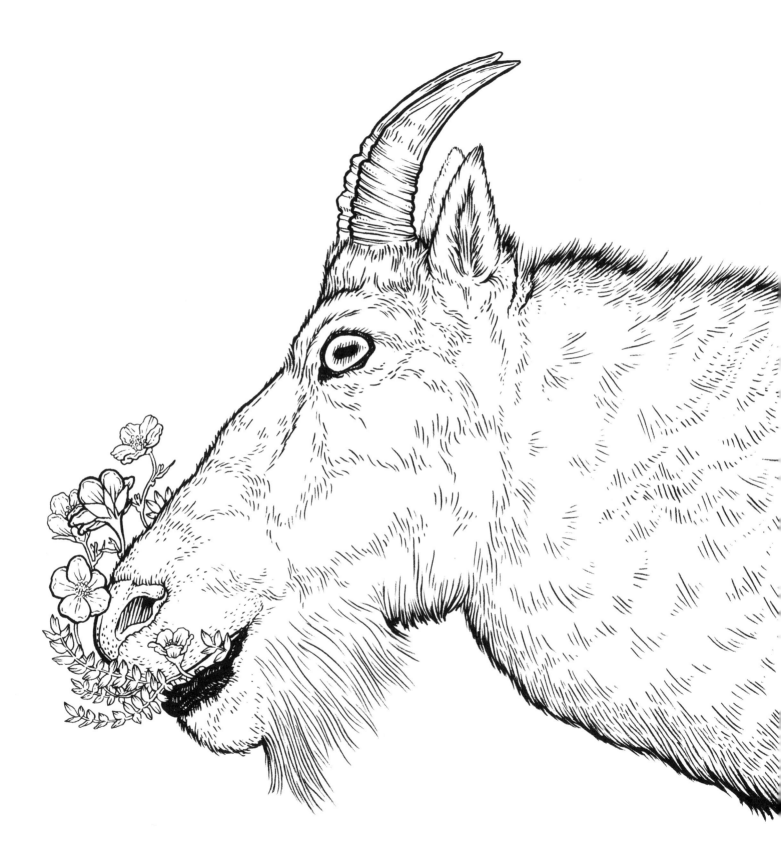

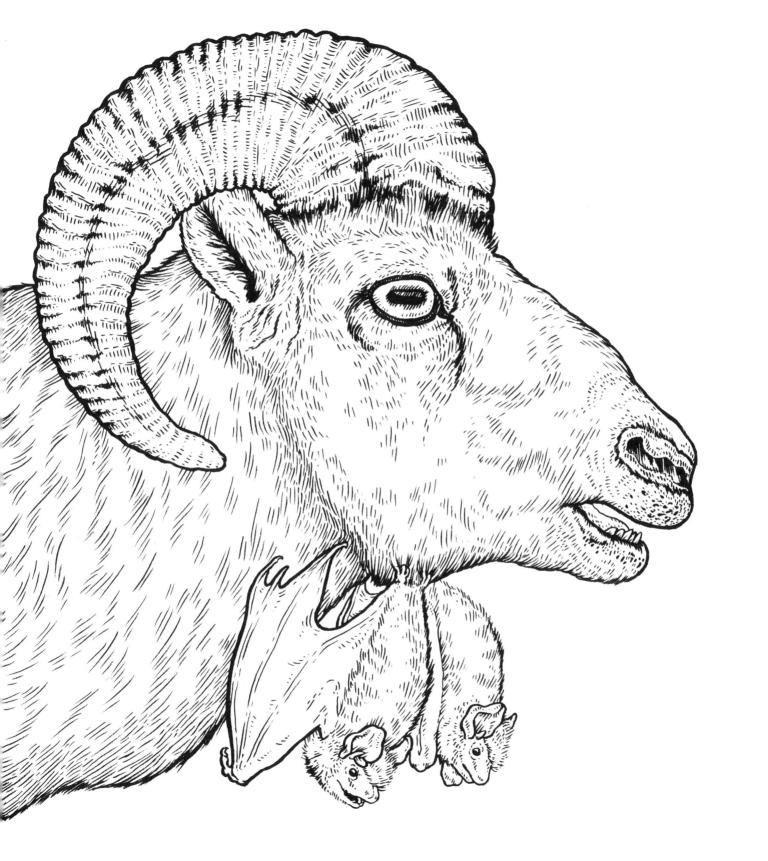

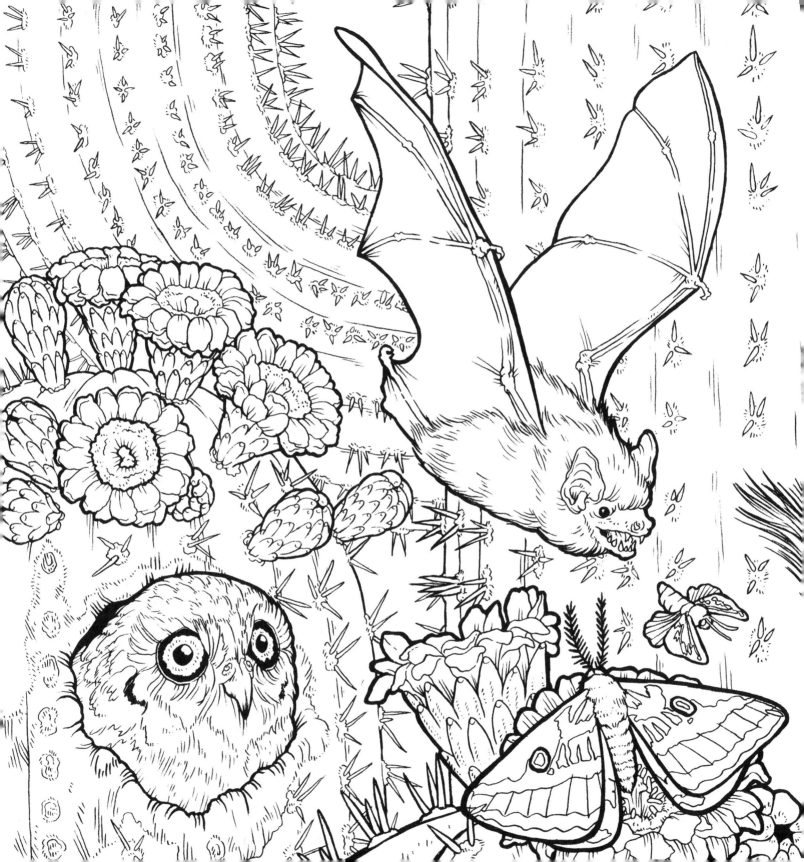

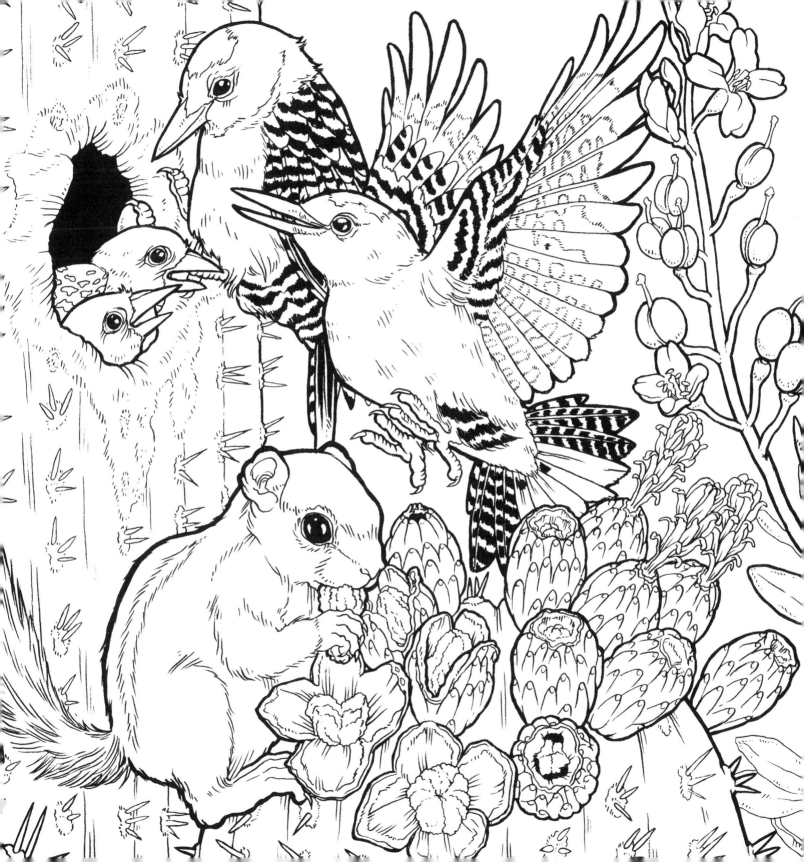

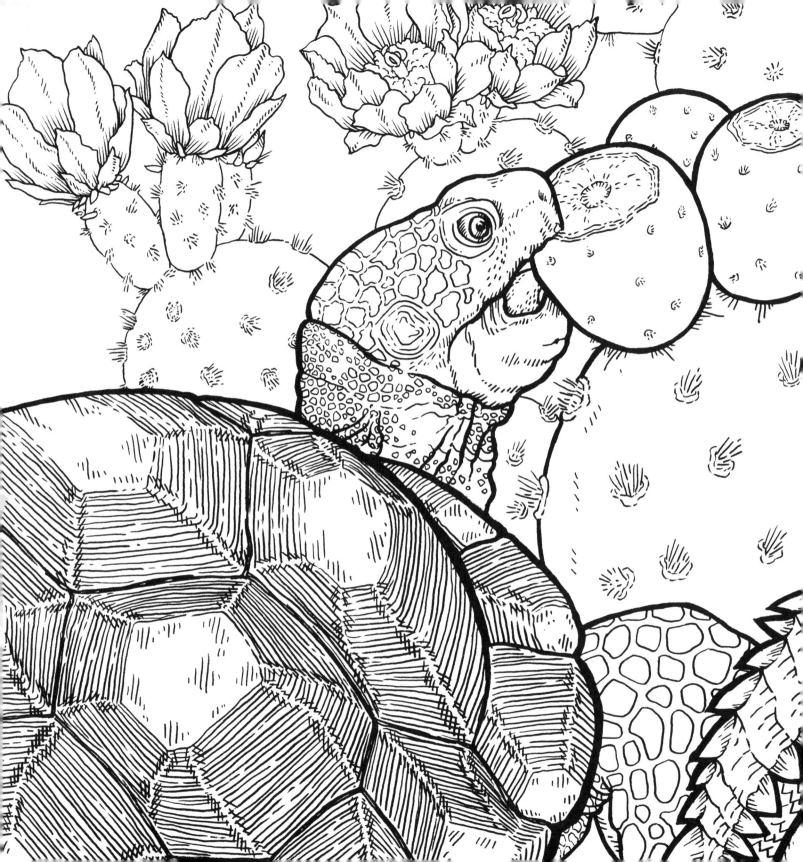

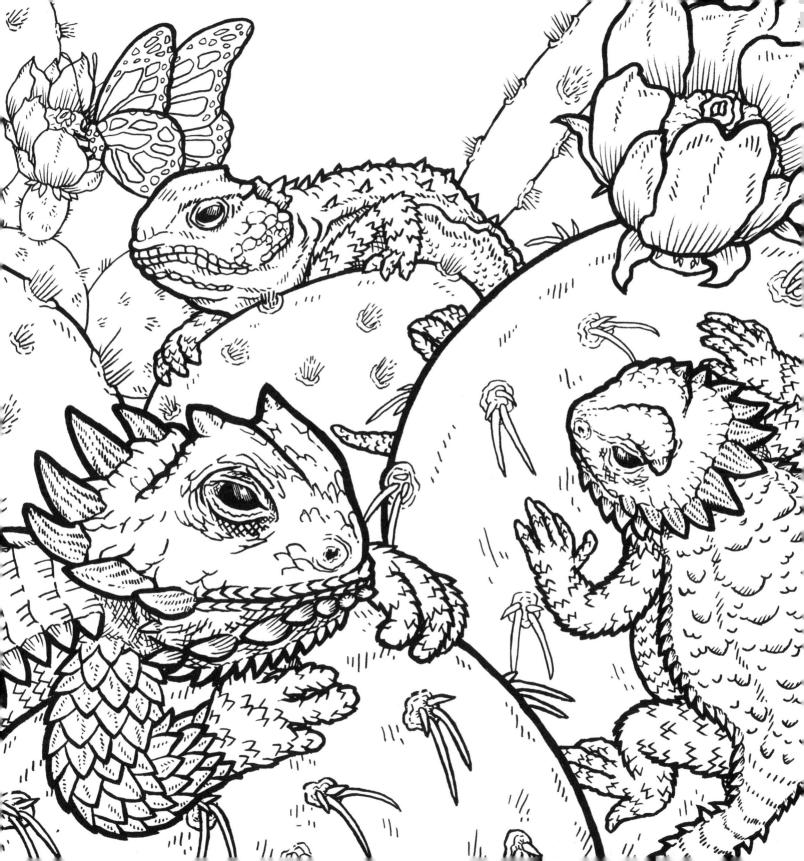

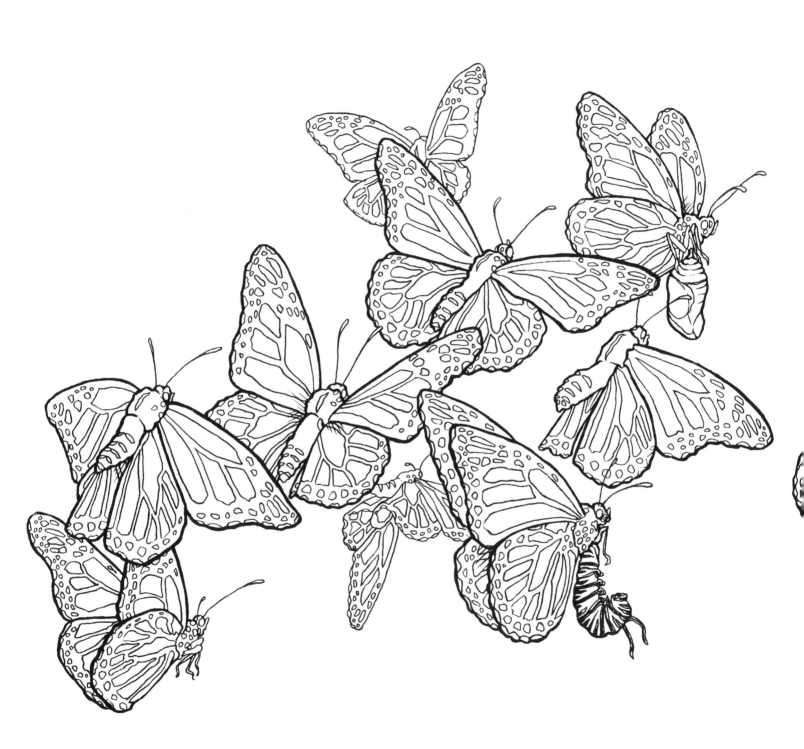

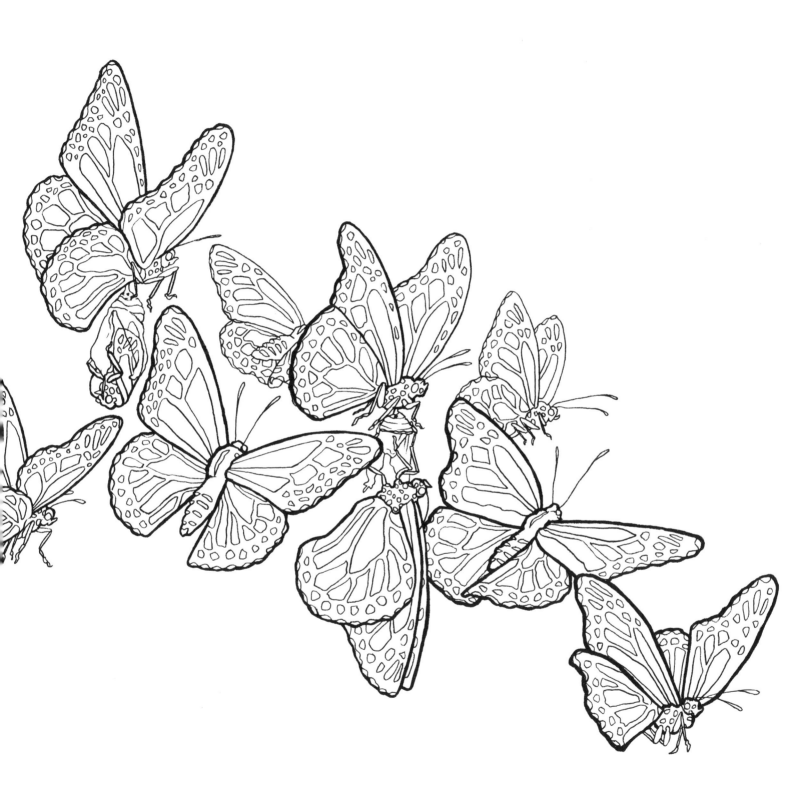

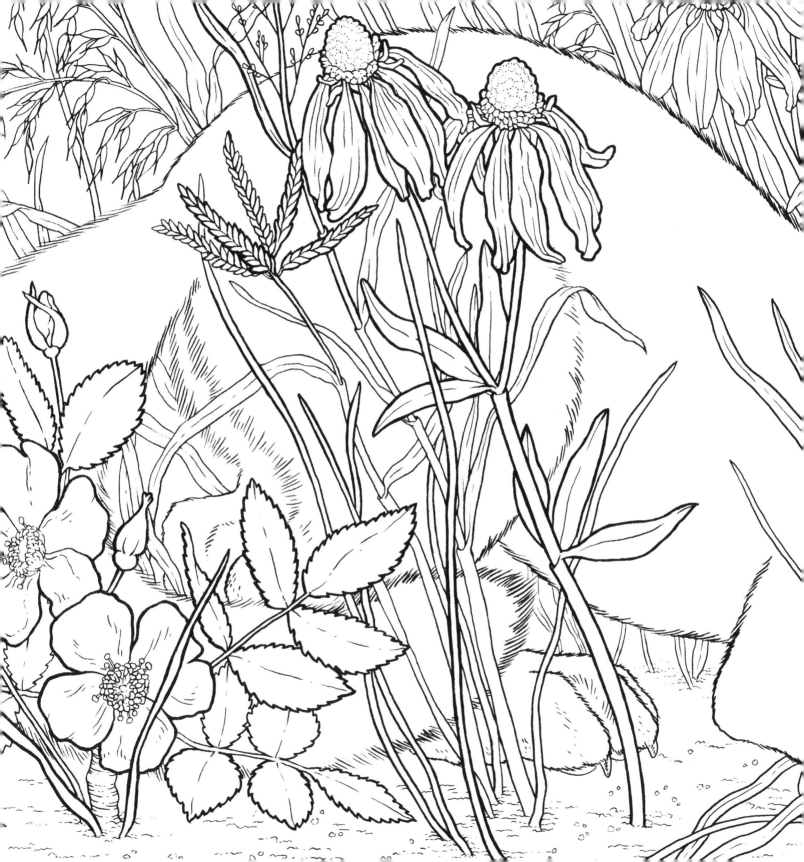

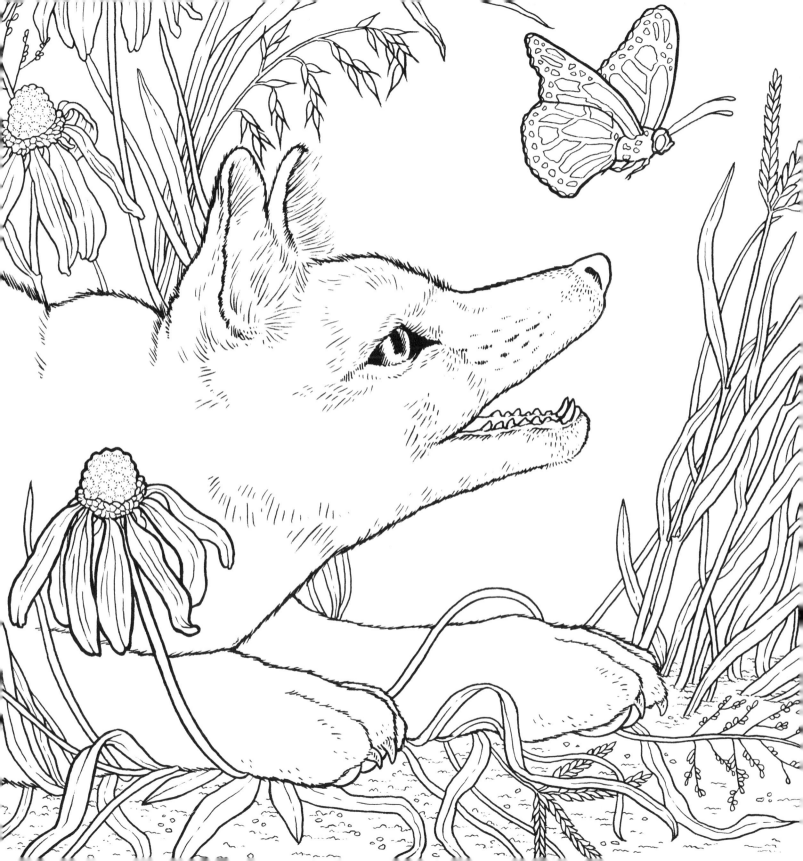

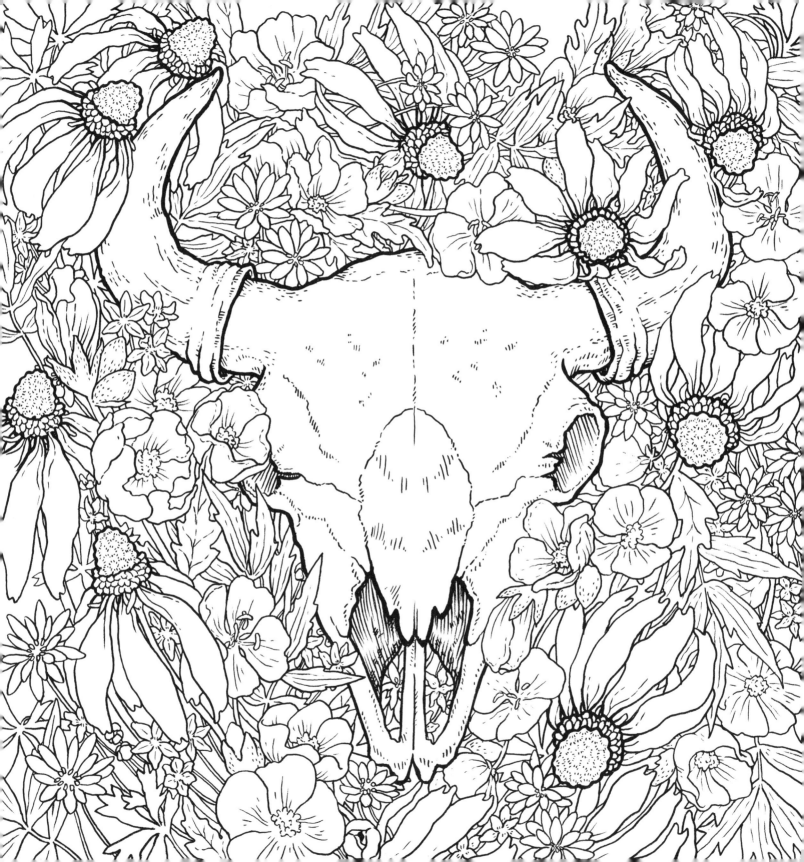

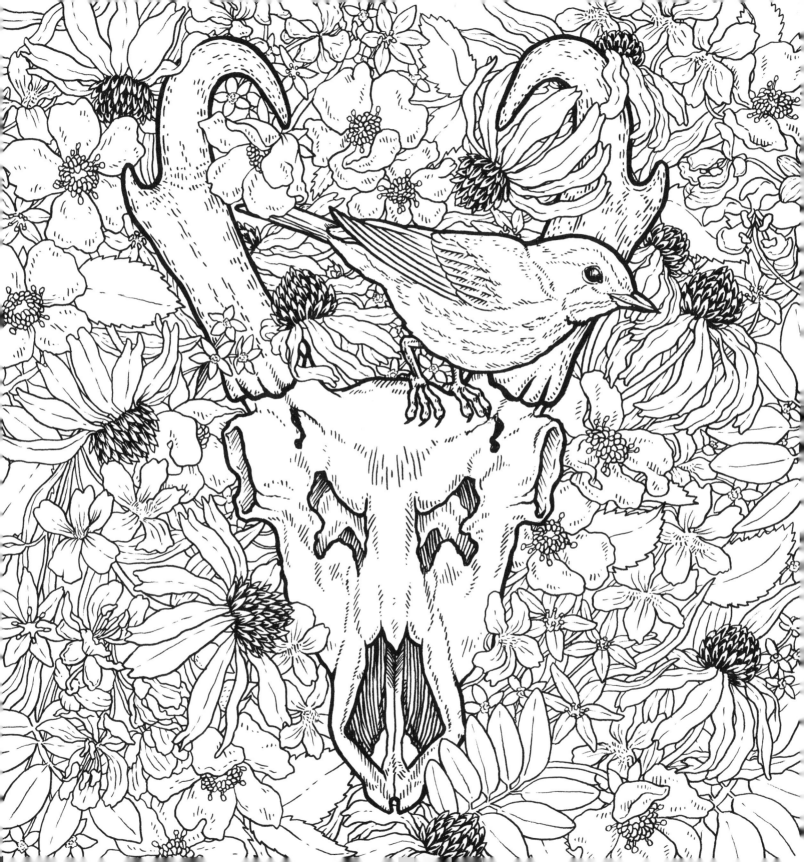

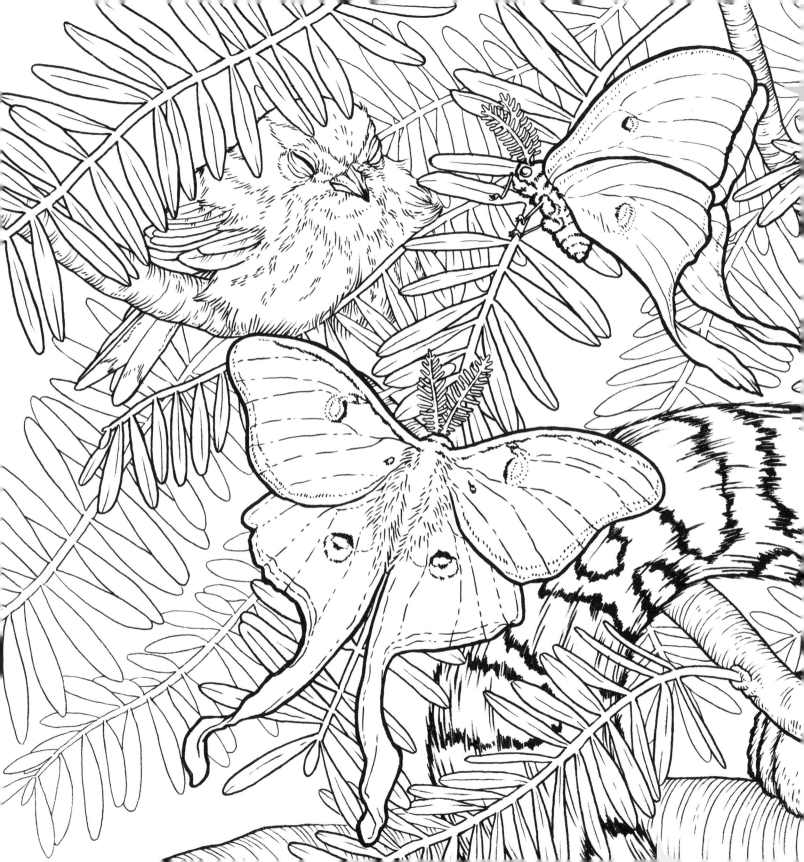

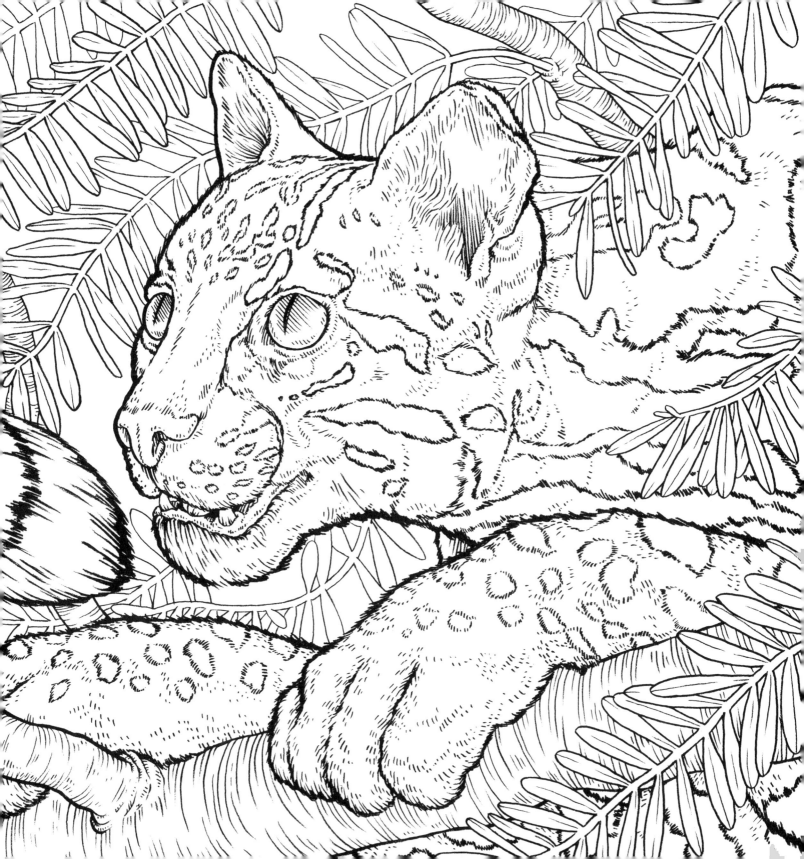

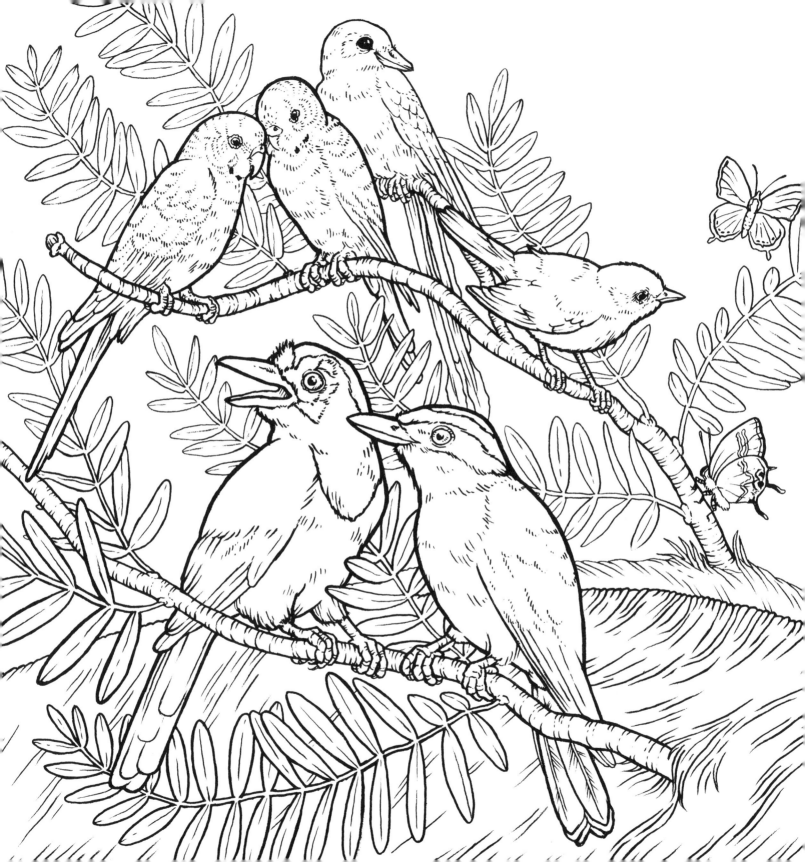

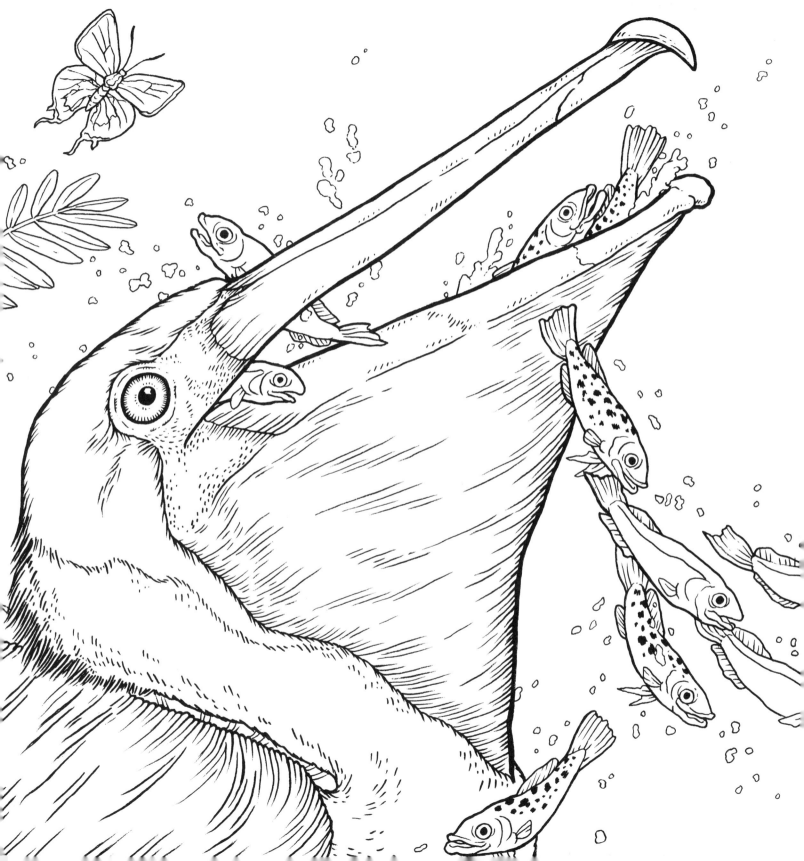

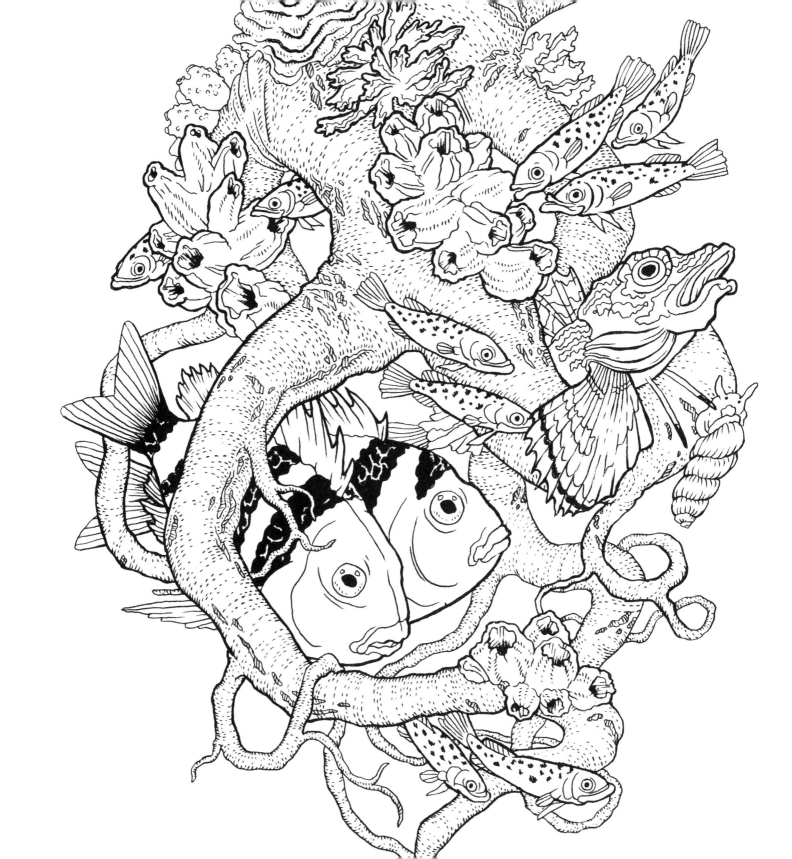

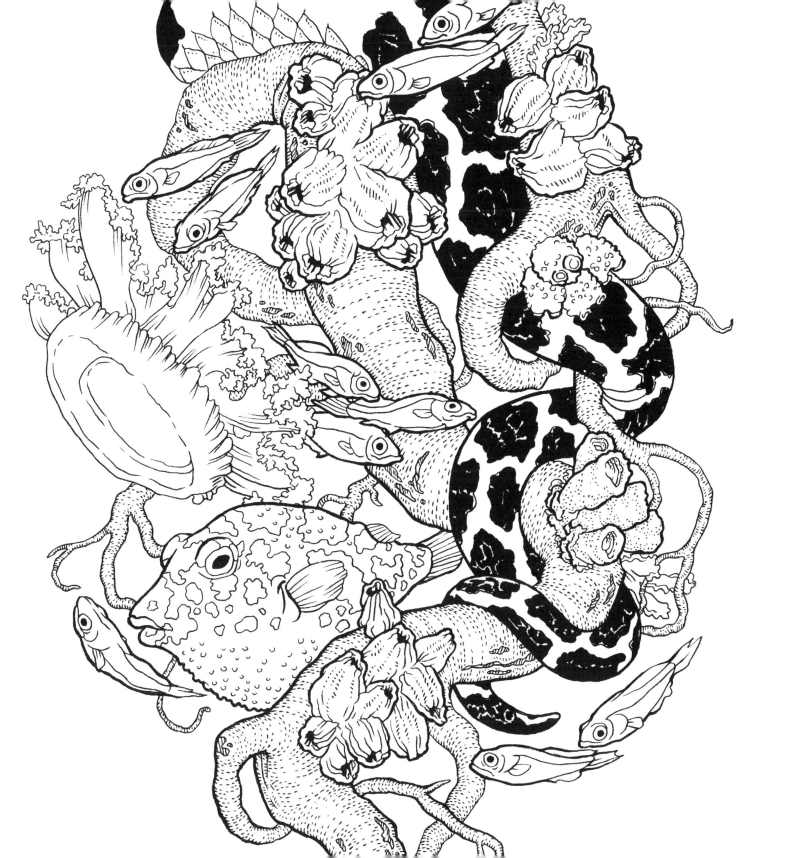

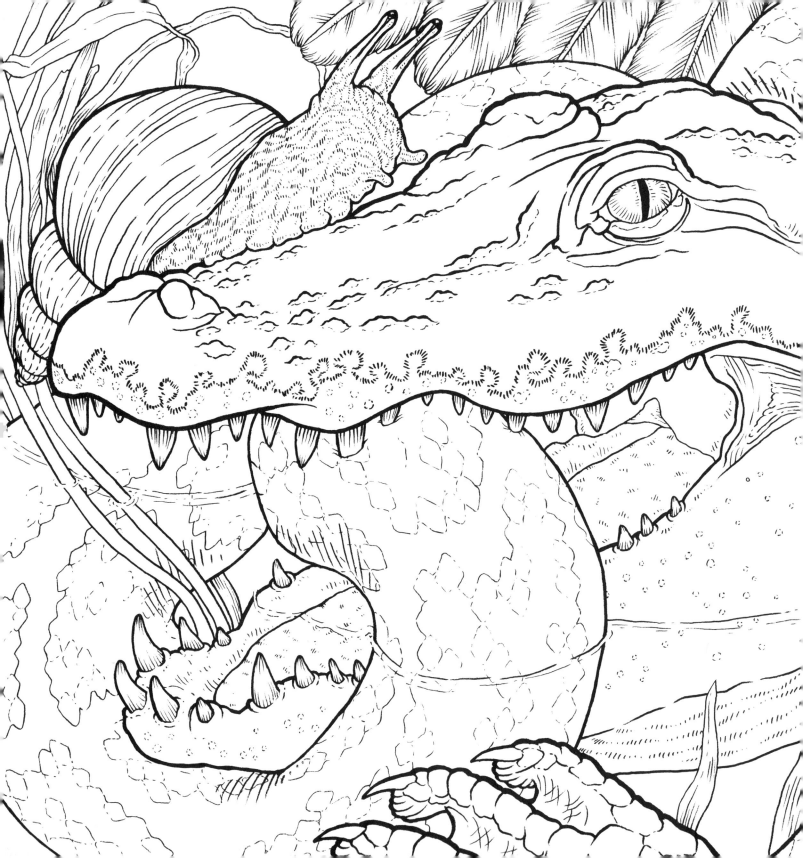

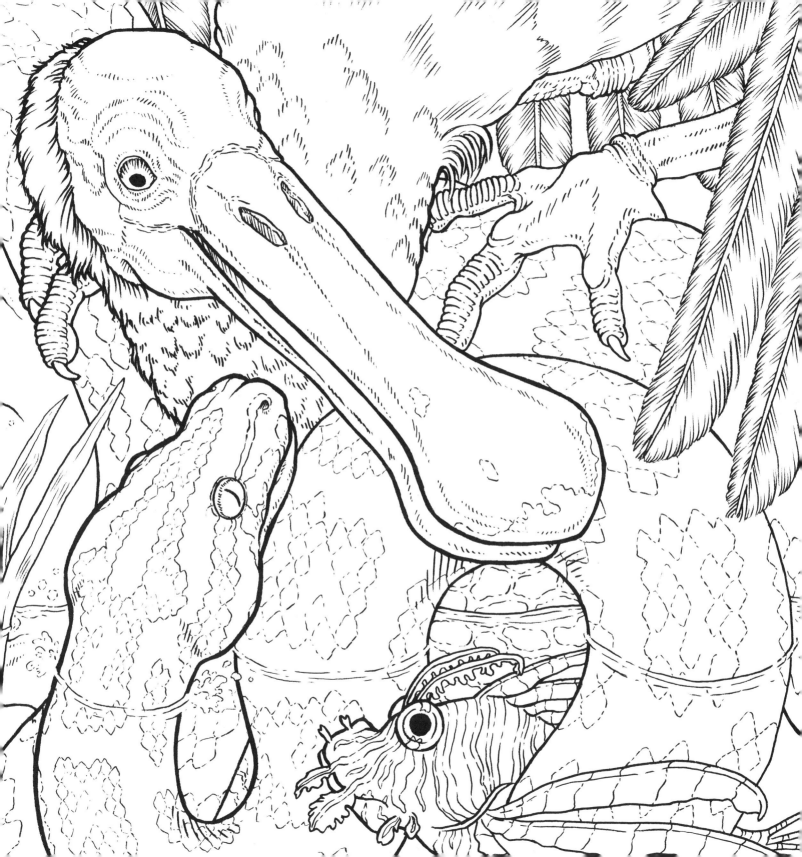

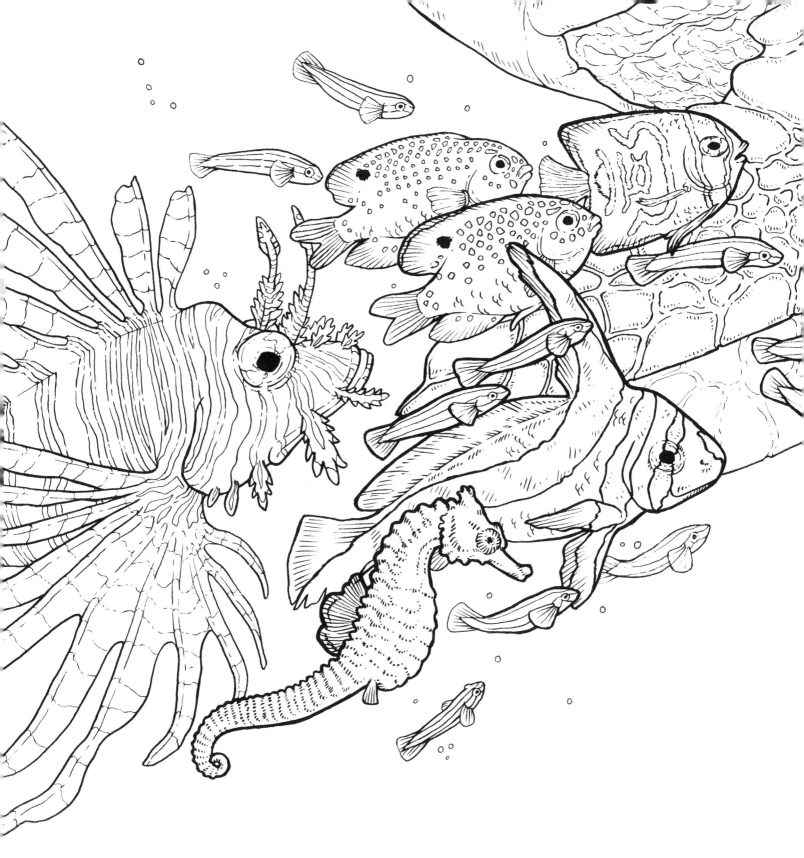

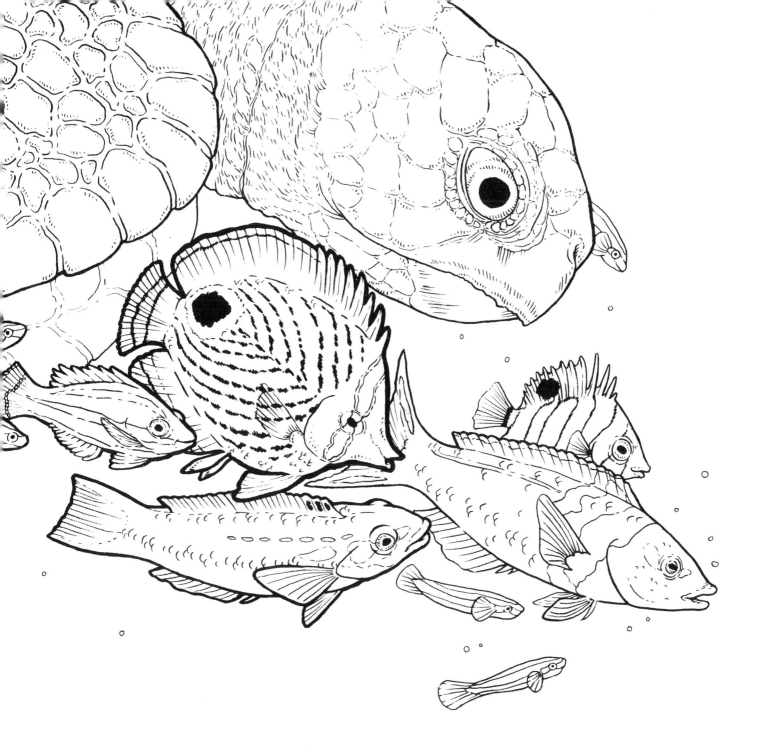

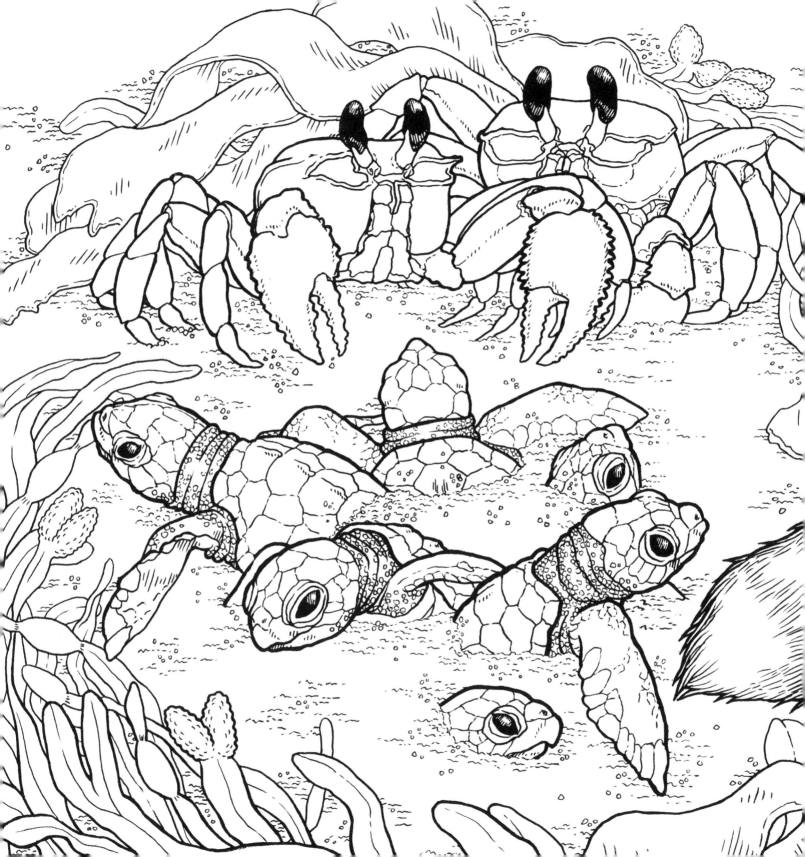

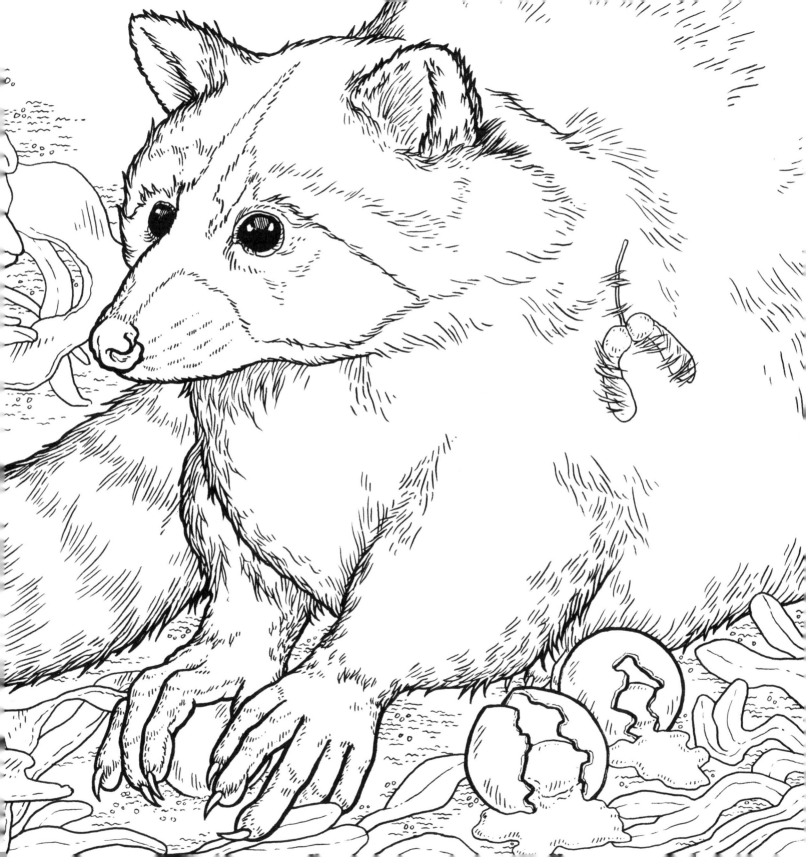

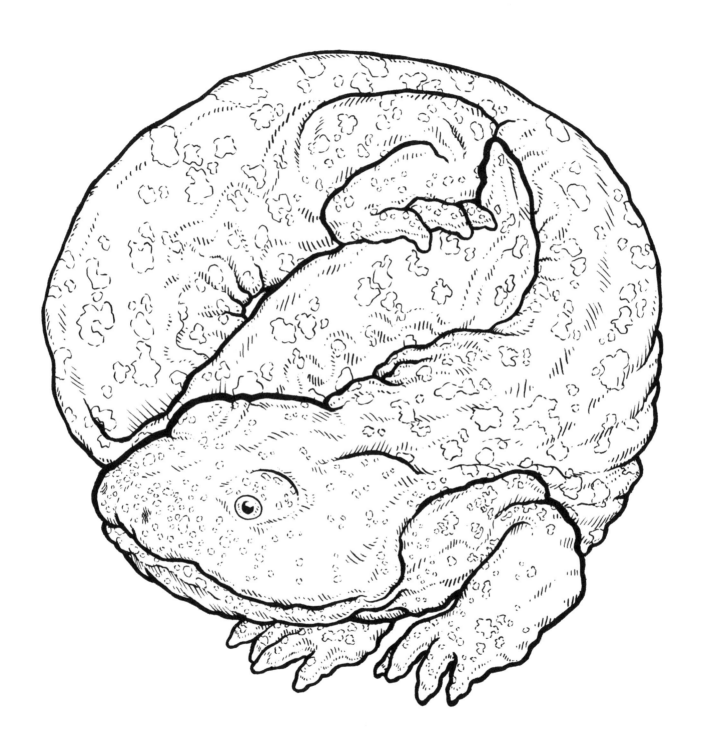

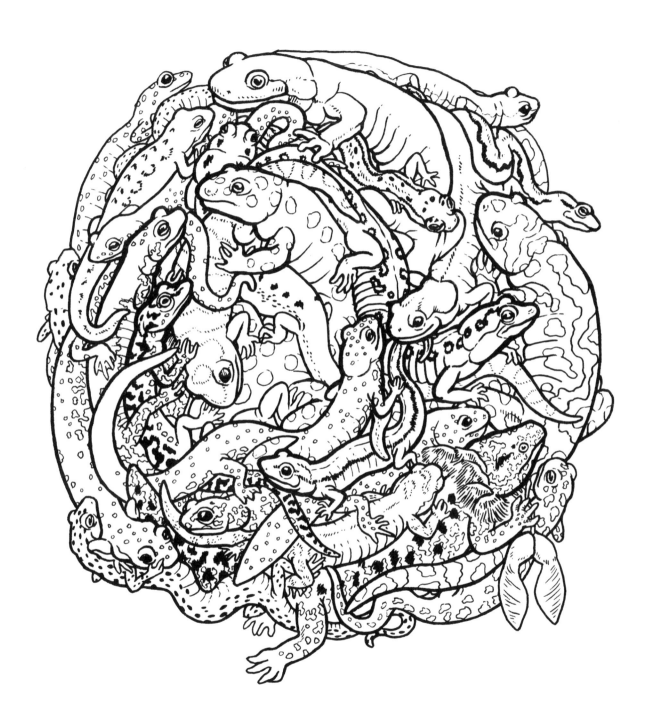

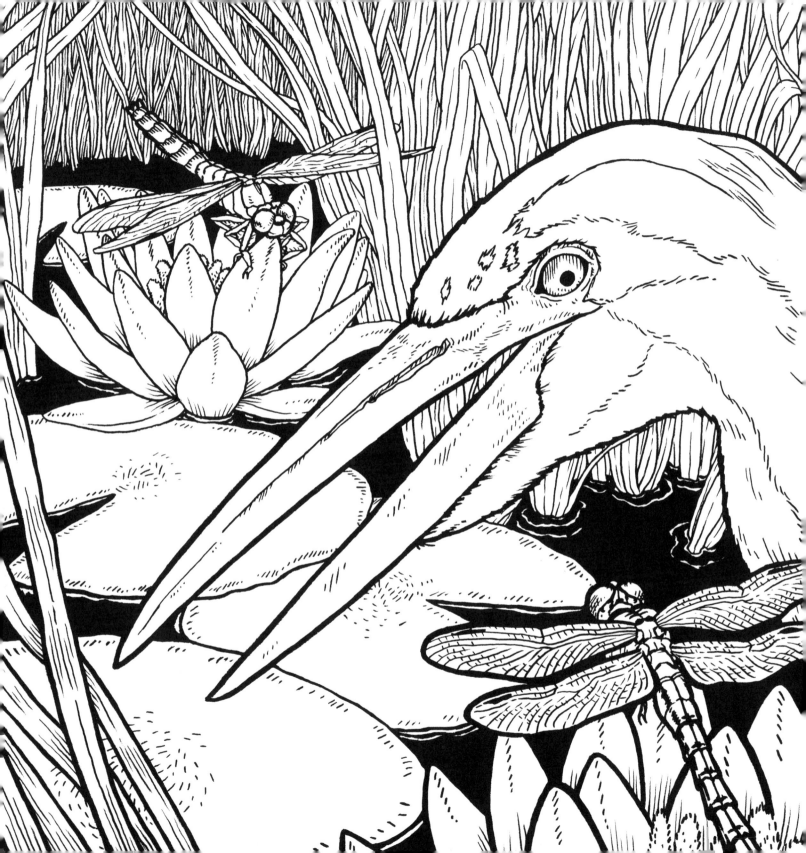

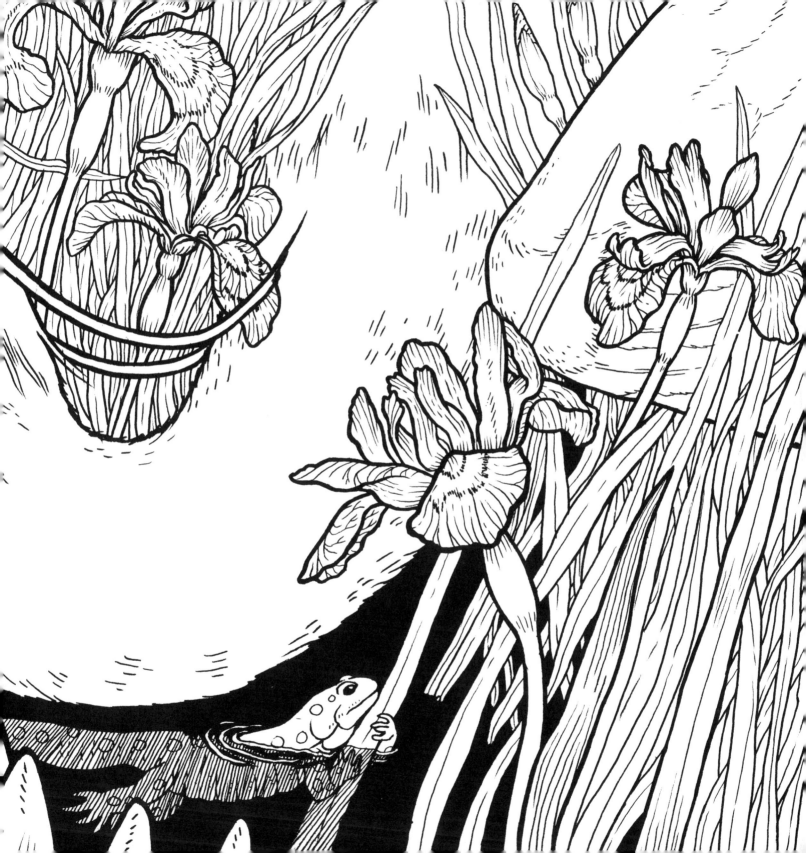

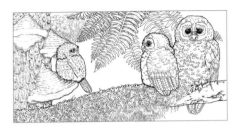

Pacific Northwest forests
A northern pygmy-owl sits on a red-belted conk mushroom. A spotted owl and owlets rest on moss- and fern-covered branches.

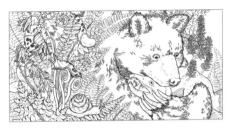

Pacific Northwest forests
Banana slugs crawl over ferns and pink fawn lilies. A grizzly bear catches a coho salmon. Spruce saplings sprout from the salmon, representing the trees that will be fertilized by the fish's remains.

Pacific Ocean
Coho salmon form a swirl showing different stages of their growth. A gray whale is visible in the distance.

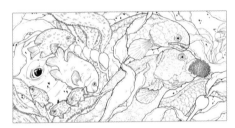

Pacific coastal waters
A gray whale peeks through a kelp forest. Adult and juvenile Garibaldi fish and wolf eels swim among the kelp. The adult wolf eel eats a sea urchin.

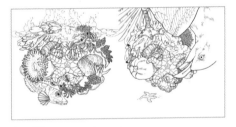

Pacific coastal waters
Tide pool creatures cling to a rock, reacting to the changing water level. *Left page, clockwise from top right:* Sea urchin, striped shore crab, opalescent nudibranch, mussels, another opalescent nudibranch, barnacles, coralline sculpin, giant green anemone, hermit crab and rockweed, with an ochre sea star in the center. *Right page:* When the tide is out, the barnacles close, the giant green anemone retracts its tentacles, the hermit crab and striped shore crab hide, and a California gull picks the ochre sea star from the rock.

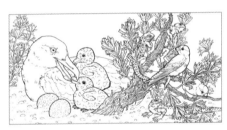

Sagebrush region
A California gull rests with its chicks. Black rosy-finches and sagebrush lizards take shelter in sagebrush.

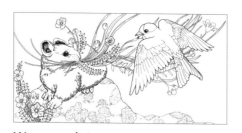

Western alpine region
A pika perches on a lichen-covered rock, holding a bundle of alpine wildflowers for its den. A black rosy-finch scolds the pika.

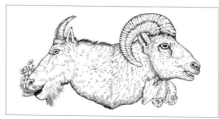

Western alpine region
A mountain goat with alpine wildflowers and a bighorn sheep with big brown bats.

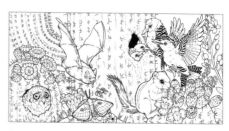

Desert Southwest
An elf owl peers out from a saguaro cactus. An insectivorous big brown bat chases a small moth. A condalia silk moth pollinates a saguaro cactus flower. A family of gila woodpeckers lives in a saguaro cactus. An antelope ground squirrel eats saguaro cactus fruit.

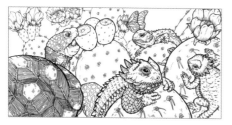

Desert Southwest
A desert tortoise snacks on prickly pear fruit. A greater short-horned lizard and two regal horned lizards sunbathe. A monarch butterfly rests on a cactus flower.

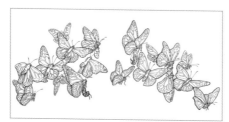

Monarch migration from the desert Southwest to the Great Plains.

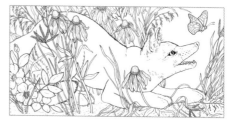

Great Plains
A swift fox crouches playfully among prairie grasses and wildflowers, looking at a passing monarch butterfly.

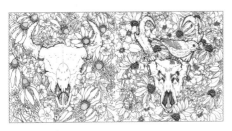

Great Plains
Prairie grasses and wildflowers swirl around the skulls of a bison and a pronghorn. A palm warbler perches on the pronghorn skull.

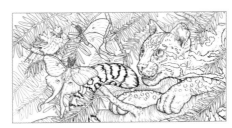

Gulf Coastal Plain
An ocelot creeps up on a sleeping palm warbler. Two luna moths sit in the branches.

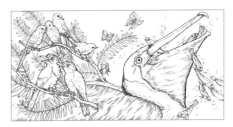

Gulf Coastal Plain
A small group of birds sits together. *Clockwise from top:* Scissor-tailed flycatcher, tropical parula, great kiskadee, green jay, and two escaped, domesticated budgerigars. Two butterflies take flight: a dusky blue groundstreak at left and great purple hairstreak at right. A brown pelican throws back juvenile red drum and spotted seatrout.

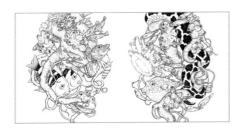

Everglades
Sponges, snails, jellyfish, and various fish take shelter among the roots of mangrove trees. At right, the tail of a Burmese python winds among the tree roots.

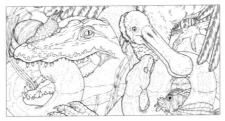

Everglades
Two keystone species—an American alligator and roseate spoonbill—defend their habitat against invasive species: a giant African snail, a Burmese python, and a lionfish.

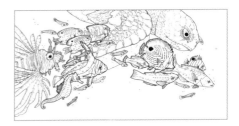

Coral barrier reef
An invasive lionfish follows fish common in the Great Florida Reef. A loggerhead sea turtle swims above them.

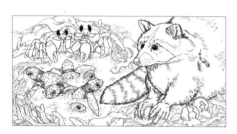

Atlantic coast
Loggerhead sea turtle hatchlings dig their way out of the sand, watched by ghost crabs. A raccoon snacks on loggerhead sea turtle eggs. Sugar maple samaras are tangled in the raccoon's fur.

Eastern deciduous forests
Left page: A hellbender shows off its patterning. *Right page:* 25 different species of salamanders huddle together in a pile.

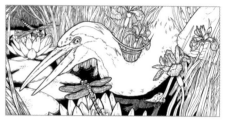

Eastern deciduous forests
A great blue heron bends through cattails and blue flag irises toward the surface of a pond. Two dragonflies rest on waterlilies. A spotted salamander prepares to lay its eggs.

SARAH MILHOLLIN

about the author

Zoe Keller is a studio illustrator based in Portland, Oregon. Using graphite and ink, she blends narrative with traditional scientific illustration to create highly detailed imagery exploring the natural world. Since graduating from the Maryland Institute College of Art, Zoe's artistic practice has taken her to studio spaces on the Maine coast, on the shores of Lake Michigan and at the foothills of the Catskill and Wallowa mountains.

Published in 2015 by Timber Press, Inc.
The Haseltine Building
133 S.W. Second Avenue, Suite 450
Portland, Oregon 97204-3527
timberpress.com

Printed in the United States
Book design by Skye McNeill
Second printing 2016

ISBN 13: 978-1-60469-718-6